MUSTARD

JOURNEY TO LOVE

Story and Paintings by
JESSEL MILLER

Mustard
Journey to Love

Text and Illustrations Copyrights © 1998 Jessel Miller

No part of this publication may be reproduced, stored in, or introduced
into a retrieval system, or translated, in any form or by any means
(electronic, mechanical, photocopying, recording, or otherwise)
without the prior written permission of Jessel Miller.

ISBN: 0-9660381-1-8
Library of Congress Number: 98-091723

10 9 8 7 6 5 4 3 2

Typography design and electronic prepress by Connie Burton
Printed by Tien Wah Press, Singapore

Publisher's Cataloging-in-Publication
(Provided by Quality Books)

Miller, Jessel
 Mustard, Book Two, Journey to love / story and
paintings by Jessel Miller ; editor Carolynne Gamble.
 -- 1st ed.
 p. cm. -- (Soft love, strong values ; 2)
 Journey to love
 Preassigned LCCN: 98-091723
 ISBN: 0-9660381-1-8
 SUMMARY: Under the Mustard Moon, a girl newly grown to
self-sufficient womanhood meets a gentle man who expands
her understanding of soft love and strong values.

 1. Love -- Juvenile fiction. 2. Values -- Juvenile
fiction. 3. Angels -- Juvenile fiction. 4. Napa Valley
(Calif.) -- Juvenile fiction. I. Title. II. Title:
Journey to love

PZ7.M5554Mub 1998 [E]
 QBI98-1092

Jessel Gallery
1019 Atlas Peak Road
Napa, CA 94558
707/257-2350
707/257-2396 (fax)

Web-site: www.jesselgallery.com
E-mail: jessel@napanet.net

~ To the Miller Family ~

I was blessed the moment we met and you wrapped me
in a hand-made quilt of love and devotion.

Arlene and Gerald ~ Mom and Dad Miller ~
your warmth and immediate embrace
will remain in my heart
and bring a smile to my lips forever.

Bill and Carol, Ron and Amy, Joyce and Bill
~ all new brothers and sisters ~
who add to the treasure
in the history box of this unique family.

And the children, and the grandchildren, and the
great grandchildren, you are the light... the future.

I dedicate this book to all of you and thank you
for sharing your wisdom and your honest open hearts.

To the finest man I have ever known
~ my husband Gary ~
You are truly the Salt of the Earth.
In your arms I am always safe, protected,
nourished, cherished, and adored.
This book is about you, your family, Grandpa Earl,
and Grandma Ada...
I imagine she was the same to you as you are to me.
I bless her for teaching you to be the
beautiful soul that you are.

And once again to my friend and editor
~ Carolynne Gamble ~
You are a rare and delicate rose.
I appreciate all the hard work we share
in creating these books and even more,
I appreciate your belief in my visions and
your willingness to dream and fly with me.

To my readers ~
your support in launching Book One
fills my eyes with tears of joy.
You are a gift to me,
and you fill my Gratitude Journal every day.
Thank you for your good wishes and support.

Mustard was raised in the country by
Loving Parents and Angel Guides.

She knew that life was a gift
and when she left home,
she took the treasures
her family had taught her and
began a new chapter in her life.

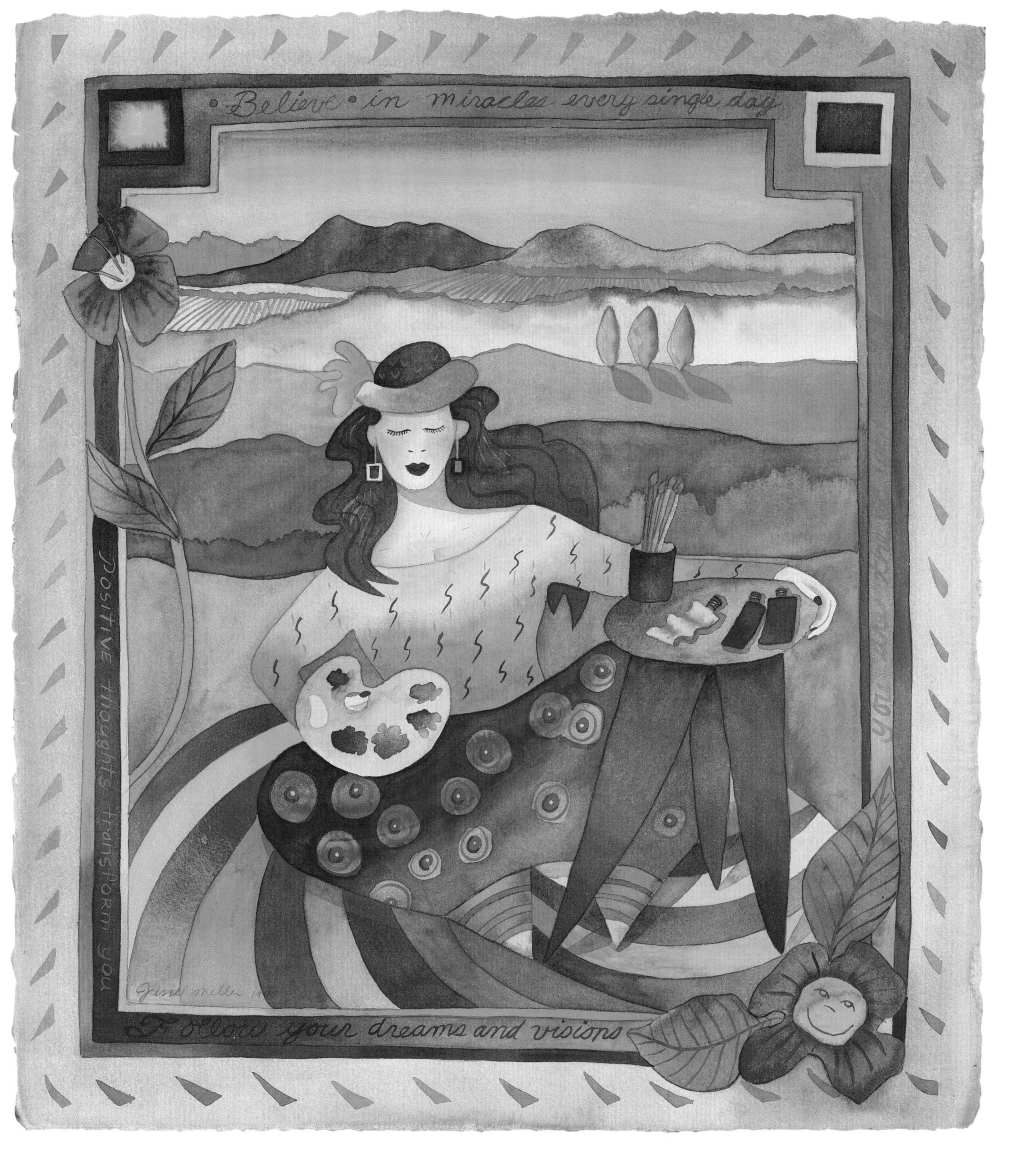

Believe · in miracles every single day

Positive thoughts transform you

Follow your dreams and visions

Living alone was

exciting and challenging ~

all at the same time!

One lovely evening,

Old Peach Tree Spirit kindly said,

"Do not be afraid

to go out on a limb

for that is where

all the fruit is!

Yet be aware

when the limb is too t h i n ~

and be cautious to s t o p

before the limb b r e a k s."

She was beginning to use her

intuition.

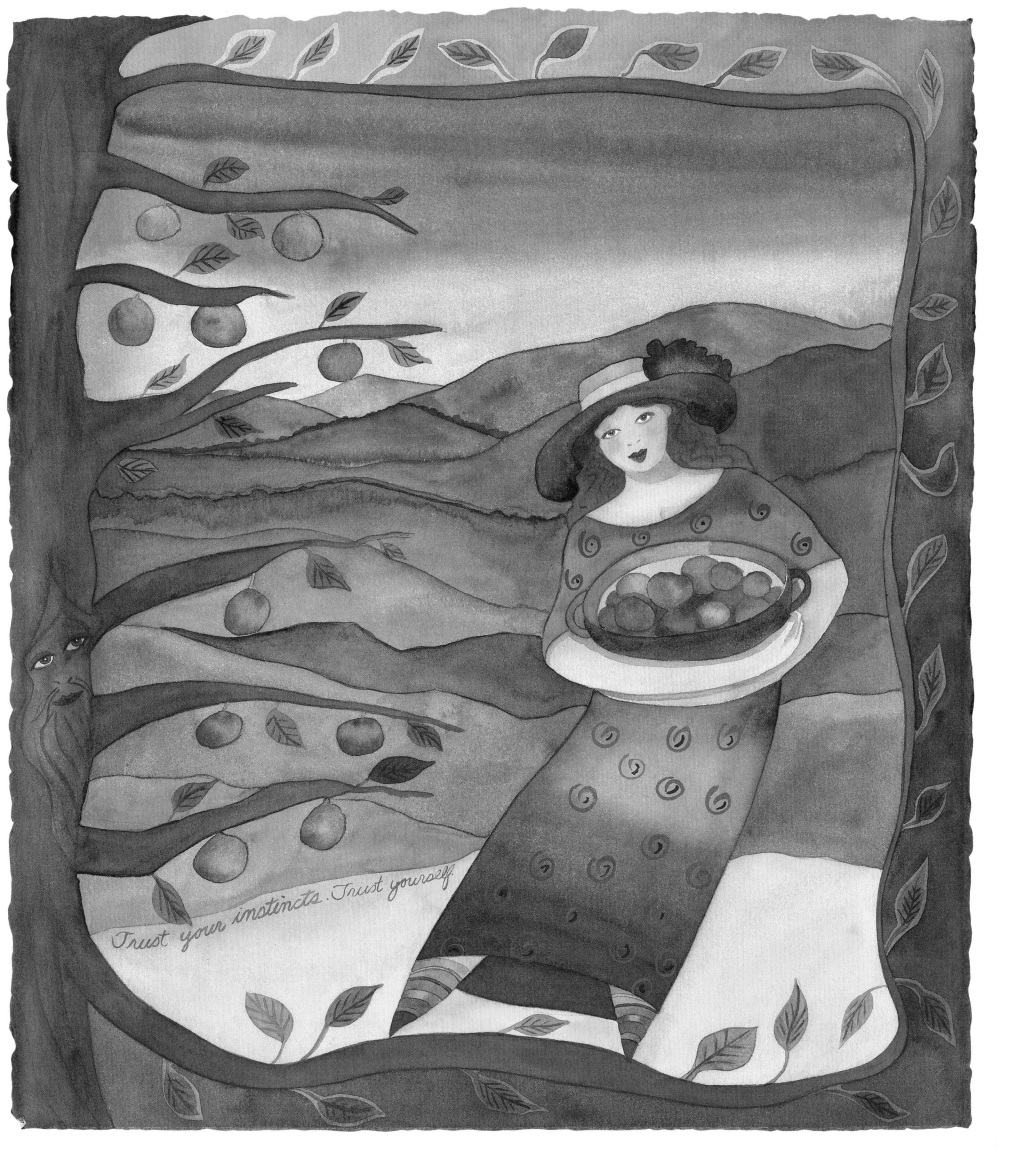

Mustard grew mellow and wise

from books and words

that told of life's mysteries

and carried her to places

far • far • away.

Her imagination stretched and thrived!

Art, music, drama ~

found in pages filled with wisdom

from those who went before.

Mustard was taught as a child

to believe in miracles every single day.

She found those miracles

in magical places ~ all along the way.

She recorded all blessings in her journal,

expressing her heartfelt

gratitude!

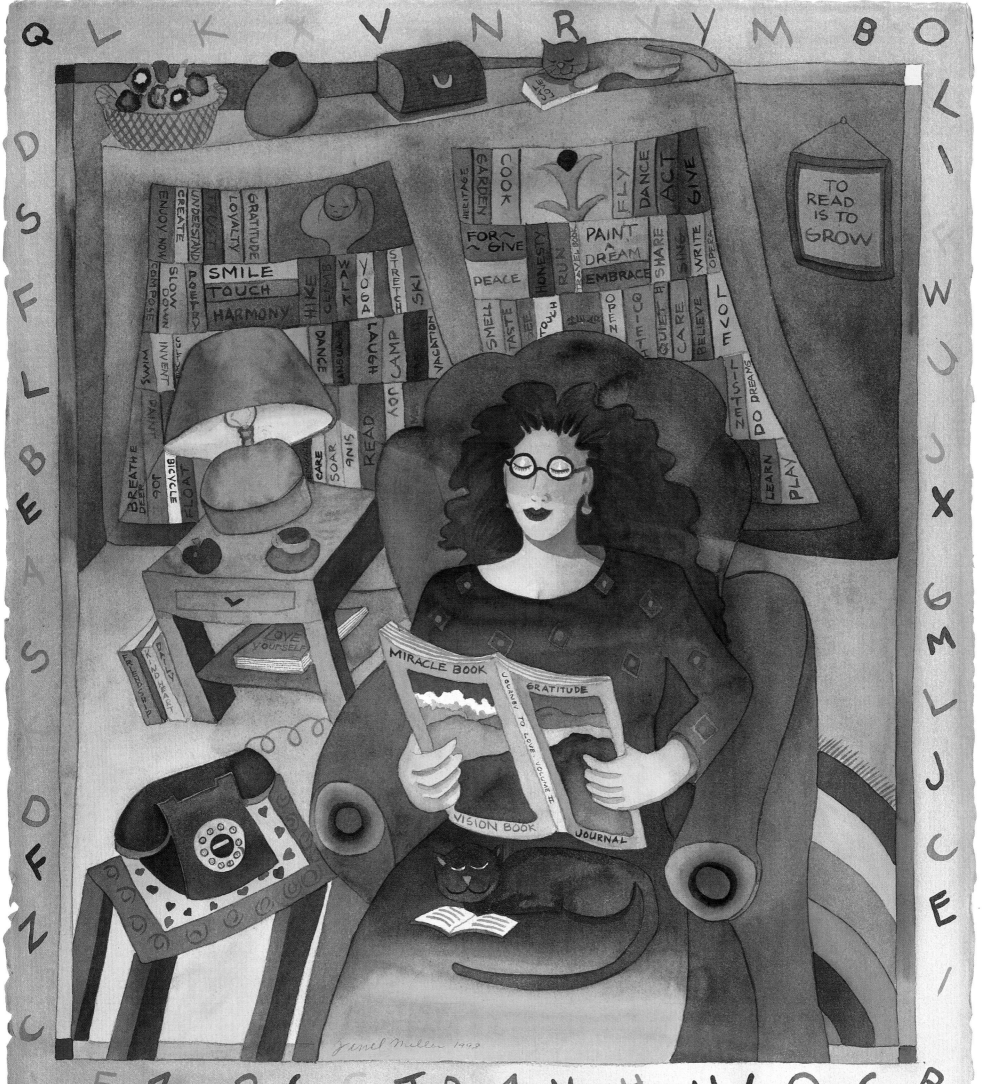

A warm bath

on a moonlit night

calmed and soothed her body.

The ducks all quacked a soft sweet sound

and reminded her to ~

cherish and savor the

quiet, gen$^t^l$e moments.

She took a deep ~ long breath

floating on the inhale and

sliding slowly into the exhale.

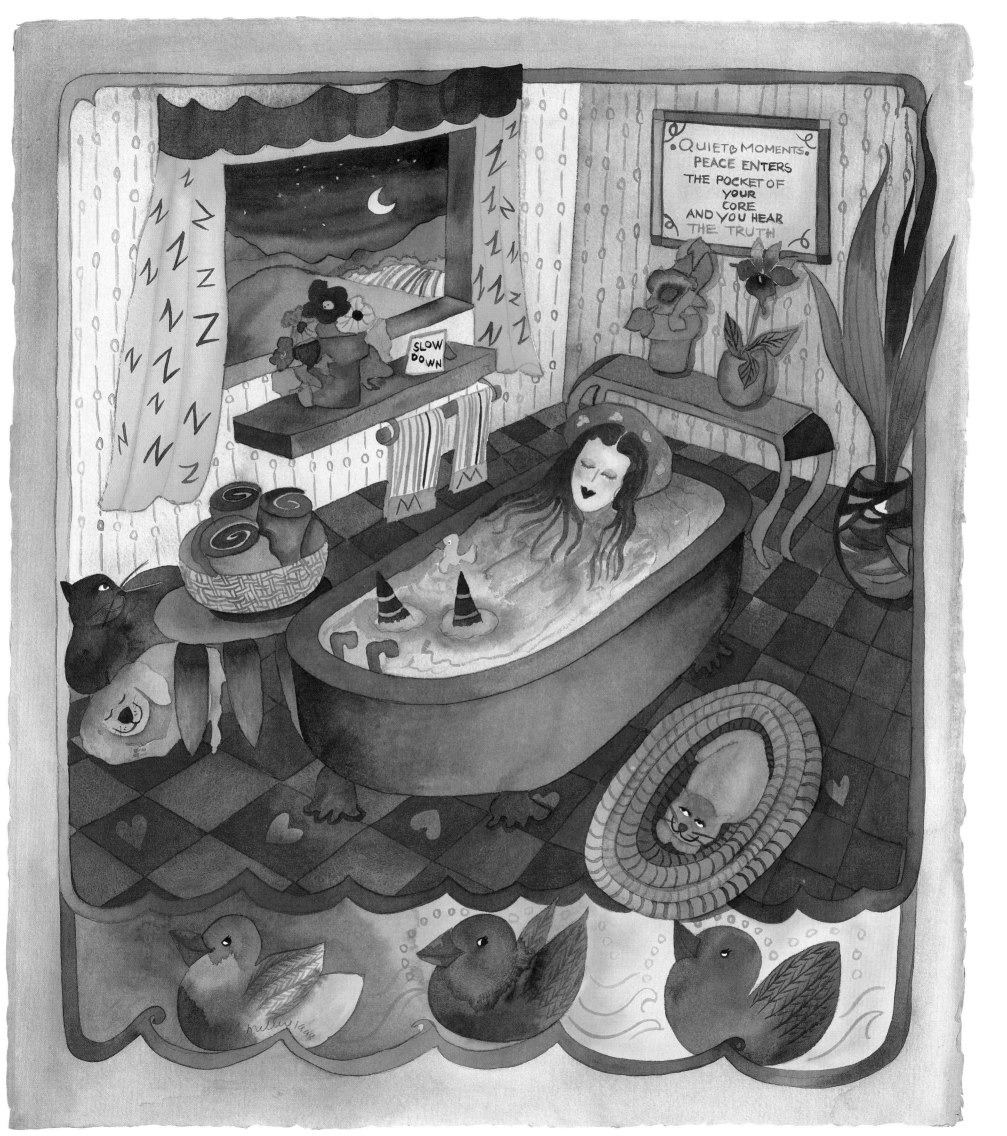

Mustard felt sad one day

when from the garden,

flew Hummingbird Angel

who whispered in her ear...

"Be a child for a day and see

the world with innocent eyes."

So she put on her Mary Jane shoes

and her hair in pigtails

and went out to play hopscotch.

She touched the ground

with joy and laughter

and her sadness turned to gladness.

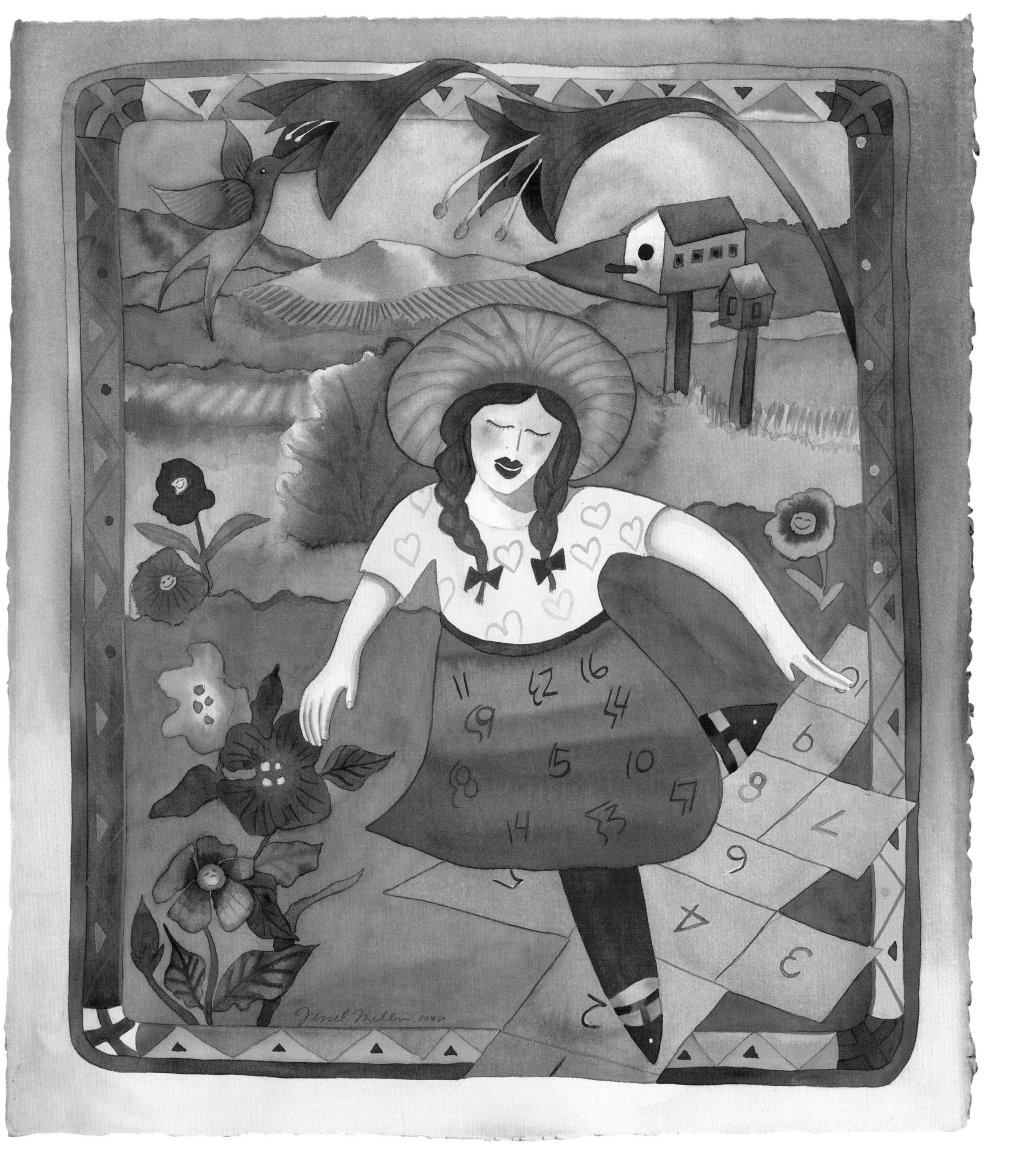

When bad things would happen,

and some days were

really really BAD,

Mustard made a giant bouquet

and gave it to someone new in her life.

She found that

giving gifts to NEW friends

brought a precious treasure

back to her...

... a glorious smile of g r a t i t u d e !

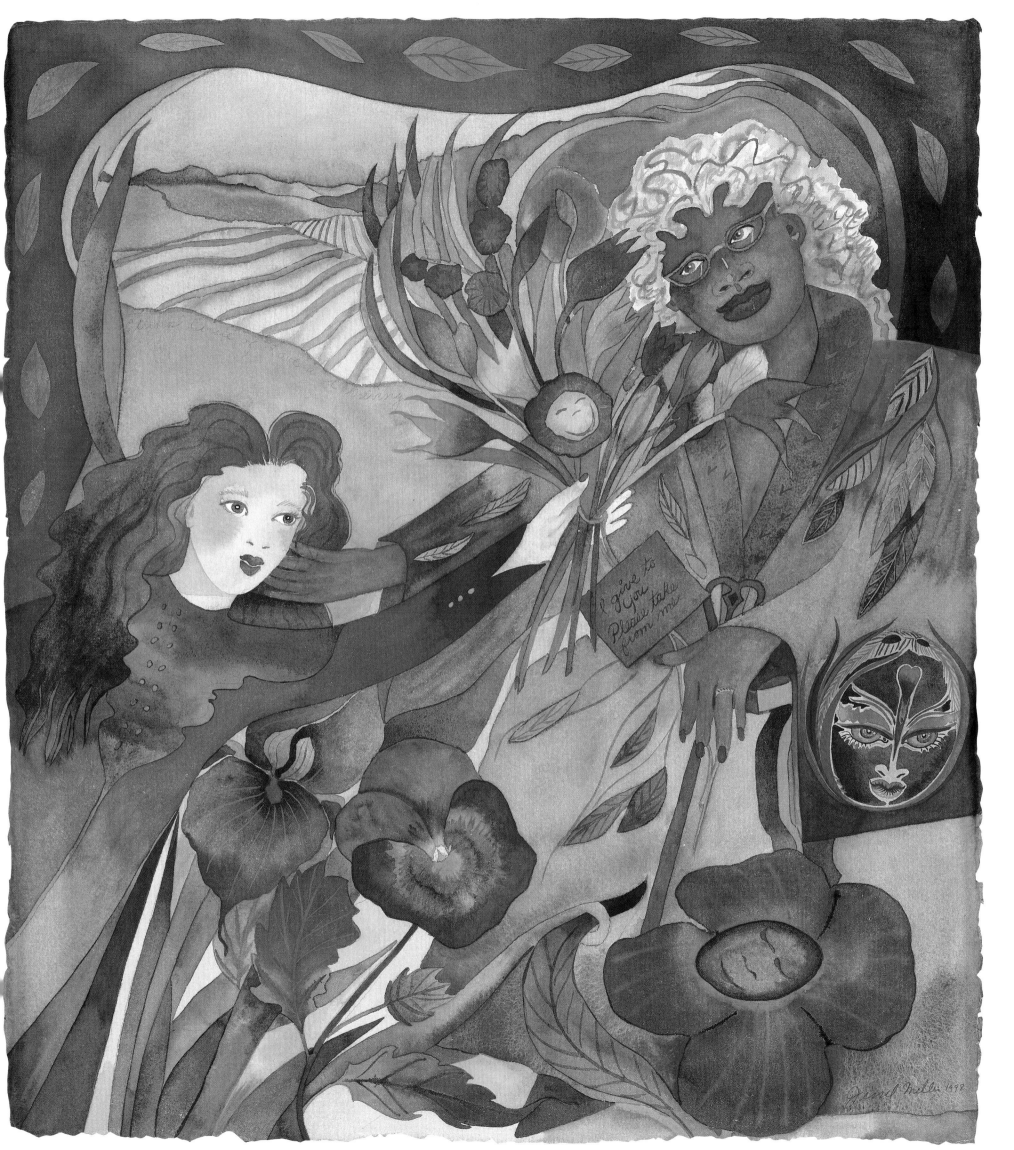

On the very worst days.

when it seemed like

everything went wrong,

Mustard would hear her mother's voice.

"Life is filled with imperfections.

Appreciate and

be grateful for

all that you have."

So Mustard made everything with apples.

And the day glowed

a R O S Y R E D.

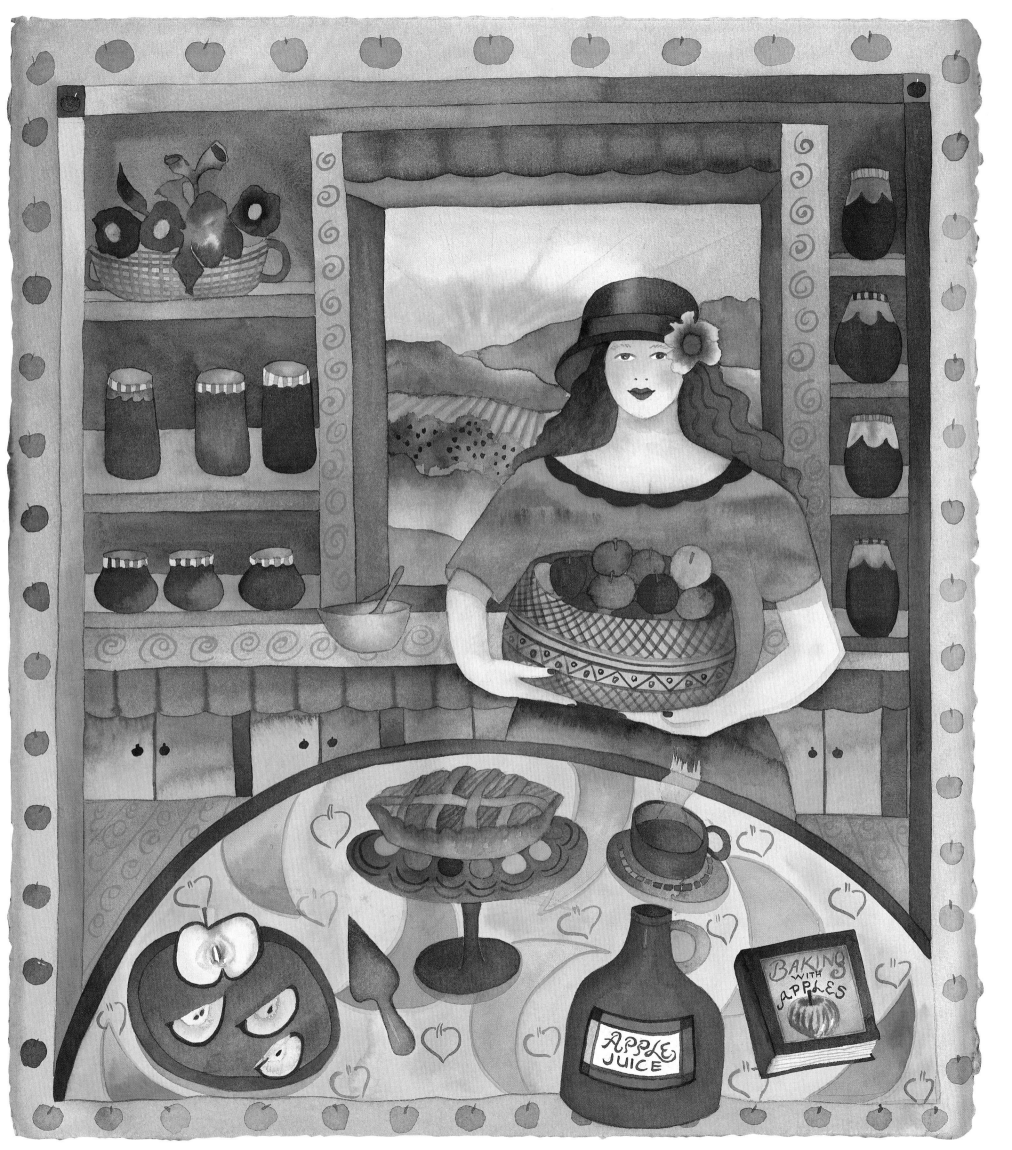

When a friend became ill,

Mustard made chicken soup

and embroidered a pillow case

with hearts and flowers

to caress a cheek

with devotion.

Kindness comes in all gestures,

and Kindness Heals.

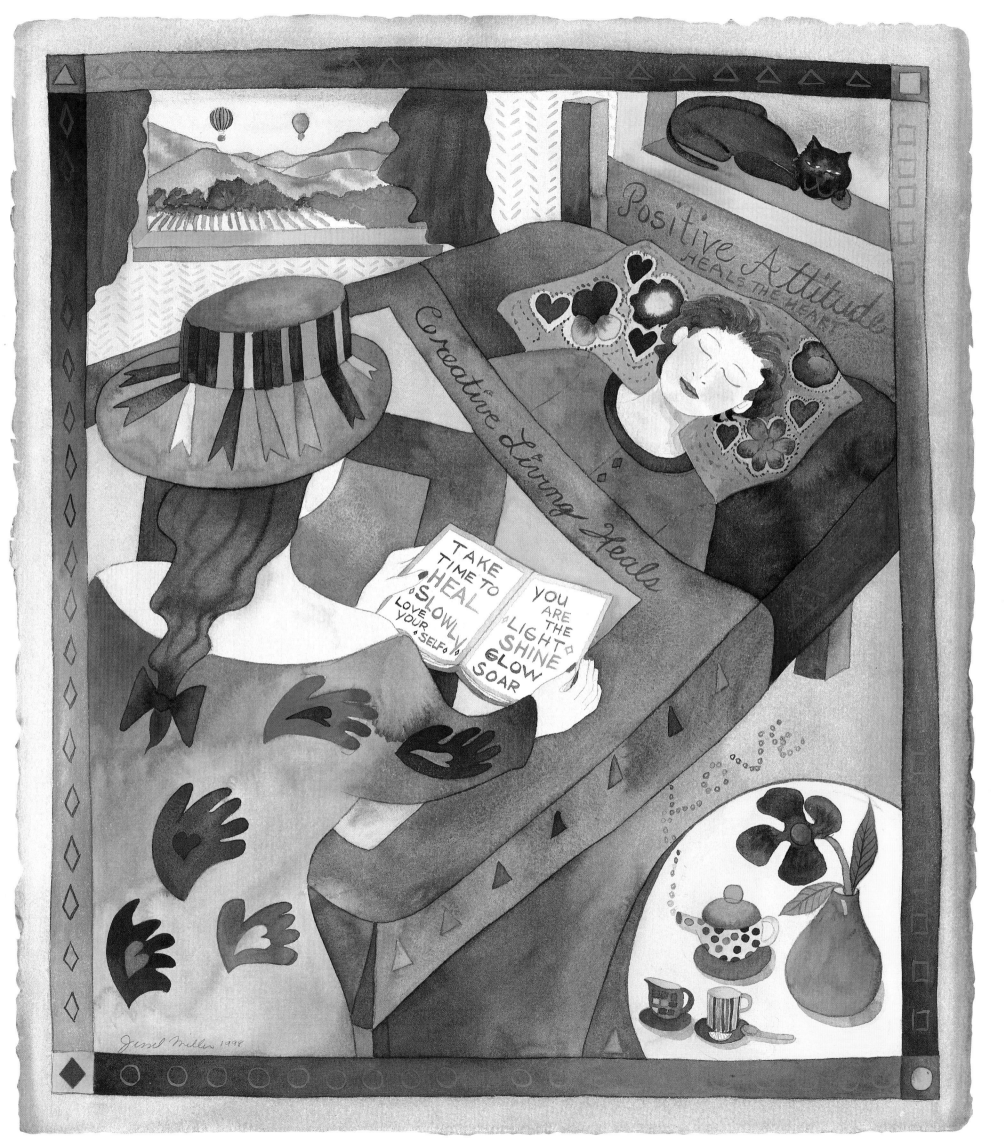

A favorite pastime was

finding heart rocks

on the beach...

If you seek them, they will appear.

She was gathering

precious memories, moments, and visions

in her basket of life.

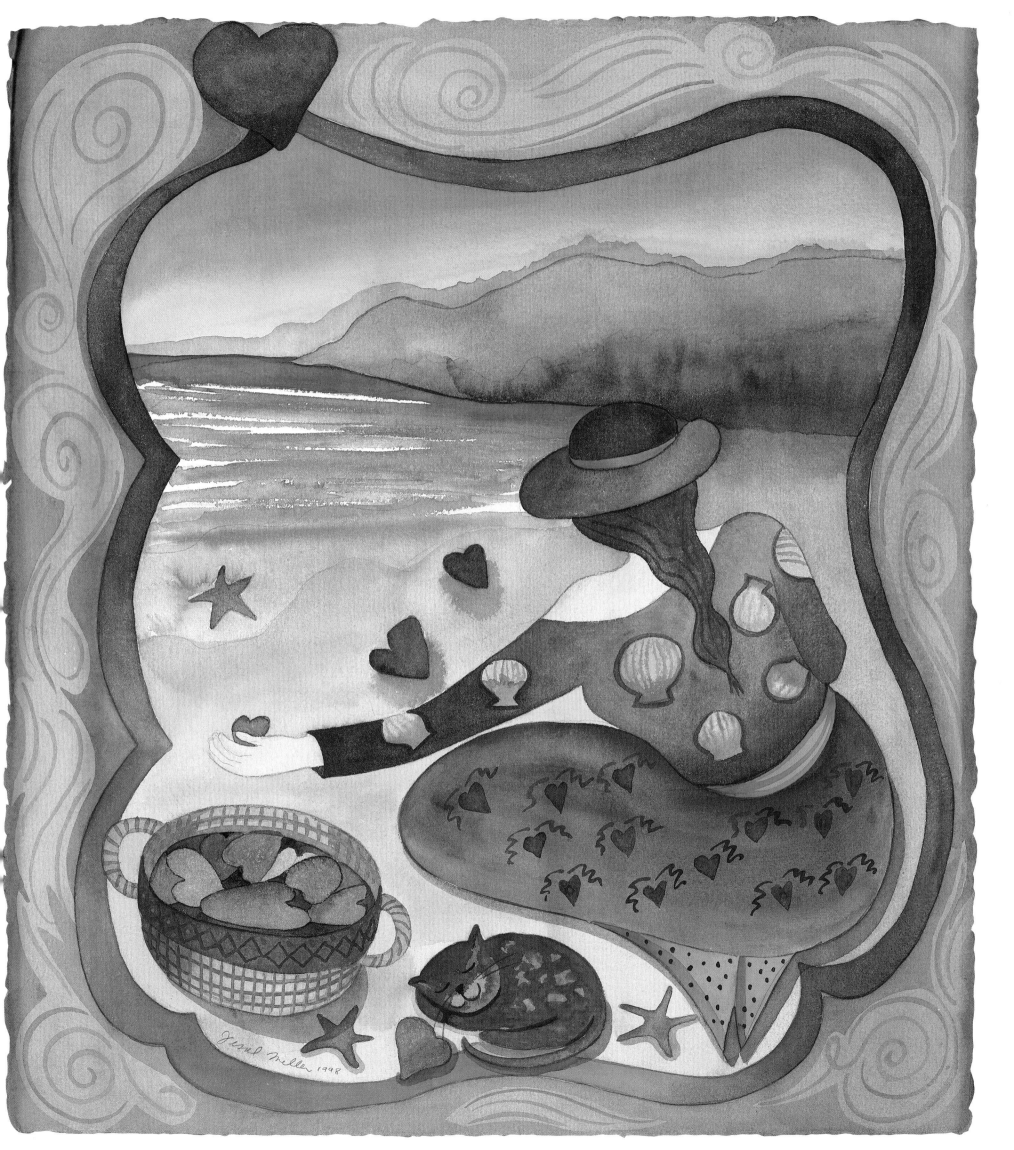

One very bright morning...

Mustard walked to her favorite

place... the Farmer's Market.

There was magic in the air and

the sky was filled with angel clouds.

She stopped at a booth surrounded by

a beauty she had never known.

A gentle man turned slowly around

and his eyes kissed her soul.

What a sense of wonder she felt!

She bought a huge bouquet of flowers,

and as she was leaving,

he gave her something ~

a handful of seeds.

"My name is River," he said.

"Plant these seeds and watch what grows."

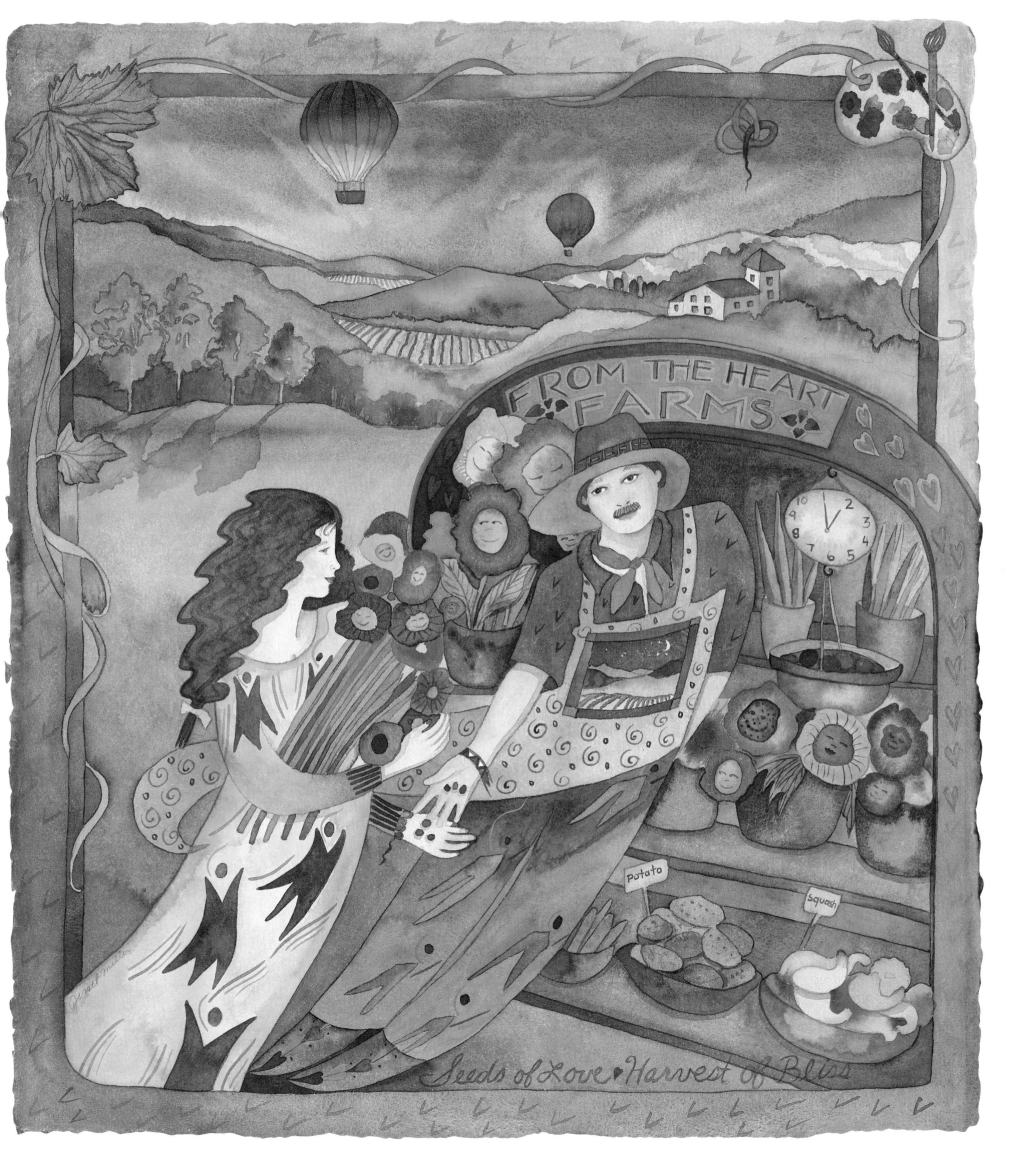

FROM THE HEART FARMS

potato

squash

Seeds of Love • Harvest of Bliss

*F*rom that day forward,

 Mustard's life changed

 and grew in a new direction.

She returned to the Market each week

 and came home with more seeds

 from her friend, River.

 Her garden

 b l o o m e d

 with beauty and bounty,

 and the fragrance of flowers

 filled the air!

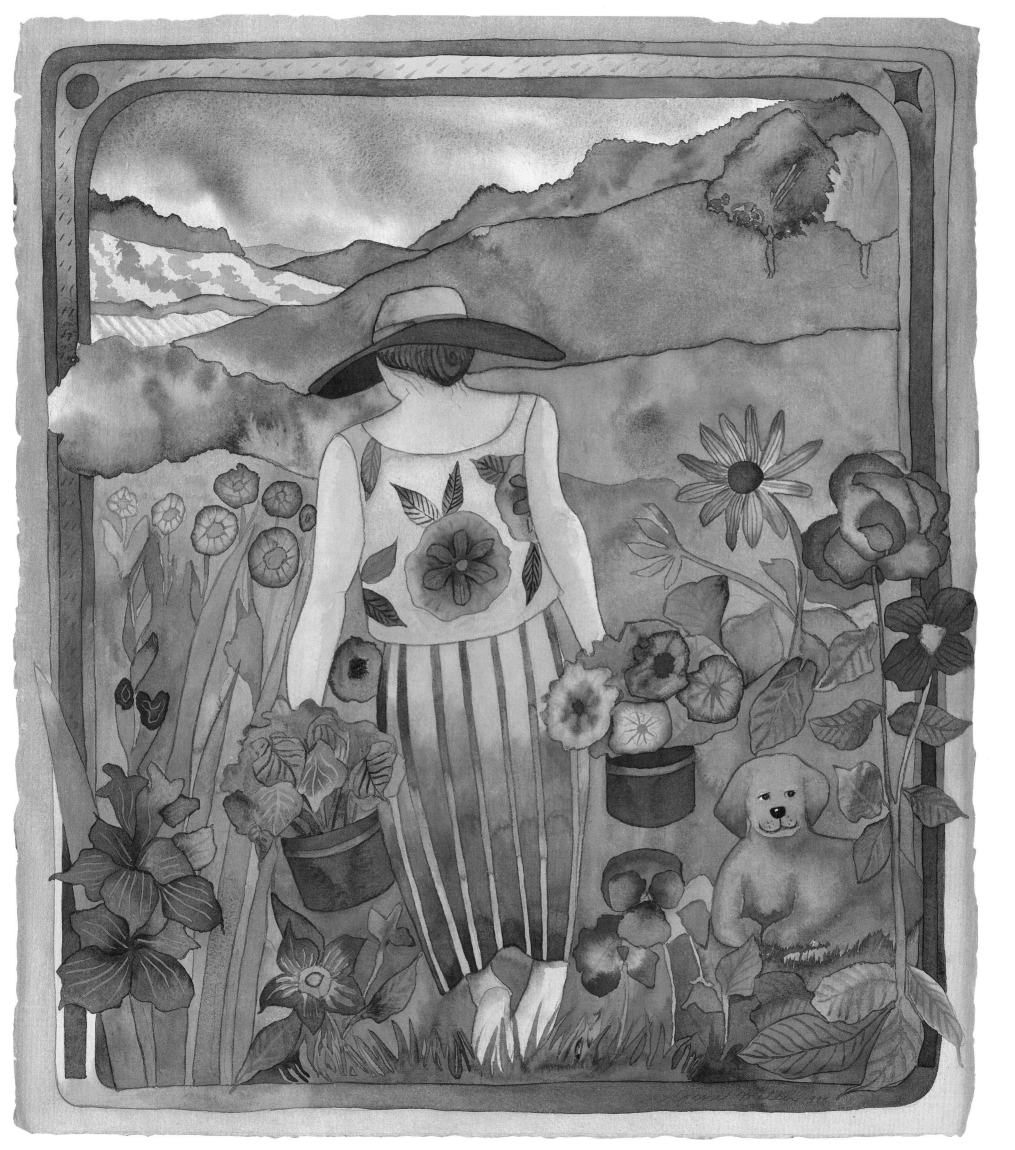

After a time Mustard invited River
to her cottage and she
asked about his family.
"How far back shall I go?" he asked.
"As far as you wish," was her reply.
And so he began,

"My great great grandfather was a farmer.
For generations my family
worked and tilled the soil,
respecting nature
for all it could provide.
As a child I learned that...

Nature cannot be rushed
no matter how hard you try!"

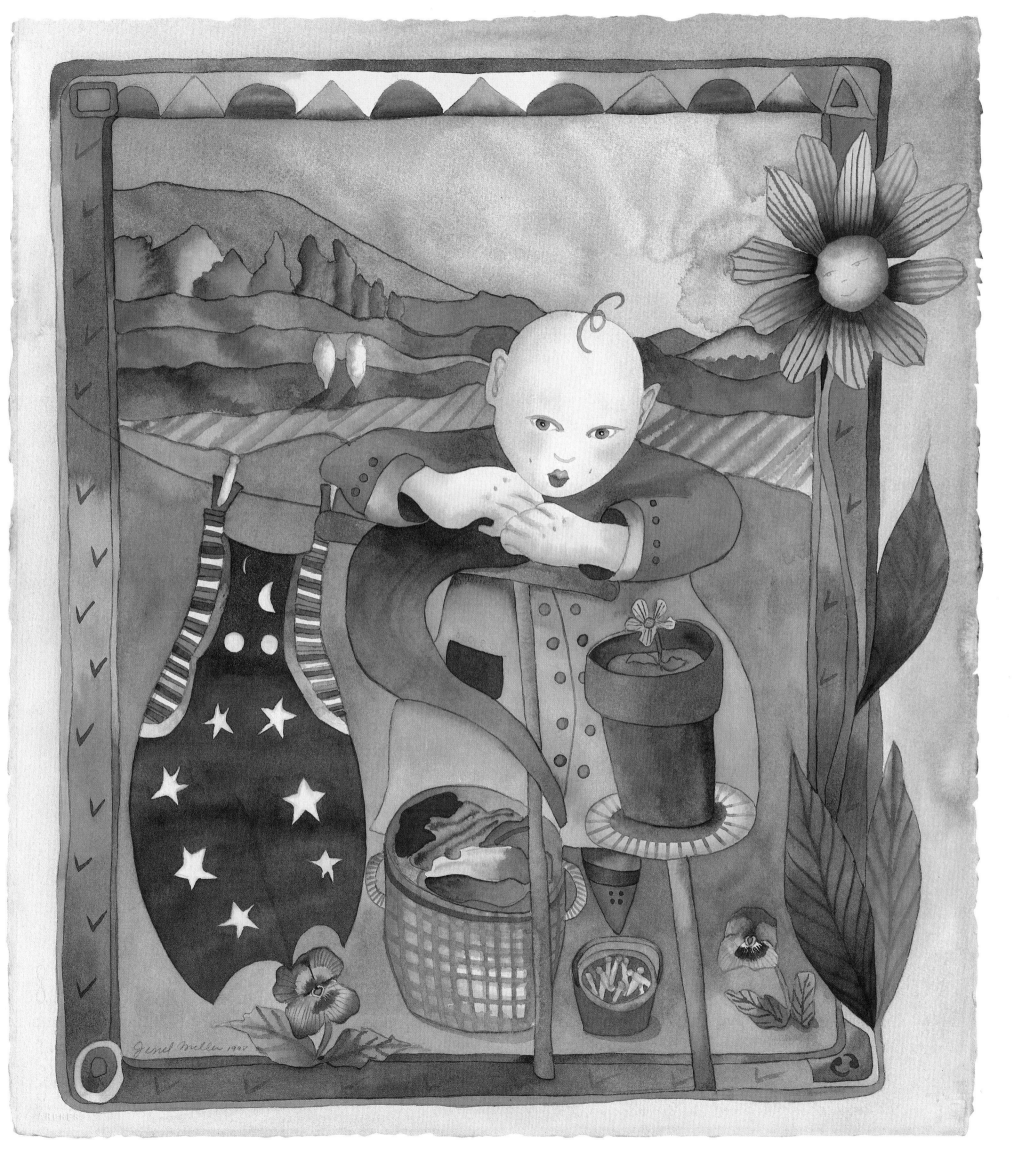

Life on the farm

 had taught him

 wisdom beyond his years.

Three generations ~

 born of the earth

 had planted his roots

 deep in the ground.

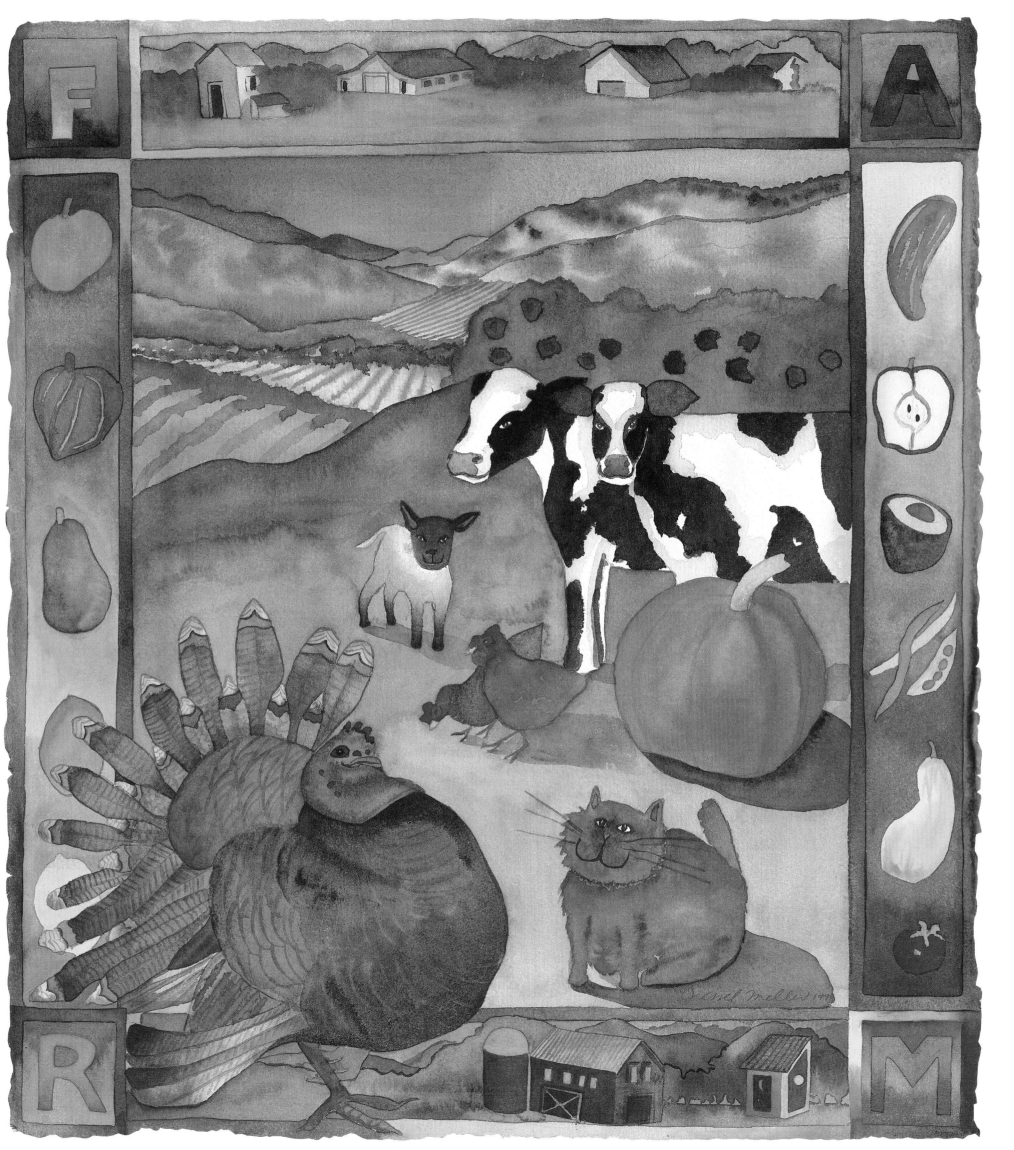

His Grandma Ada had shared her
dreams and held him close and
told stories of his heritage.
She spiked his hair and sewed his clothes,
yet taught him that c h a r a c t e r
is not what one wears or how one looks.
It is h o n e s t y,
c o u r a g e, i n t e g r i t y,
and how we treat others...
These qualities form
a strong and honorable c h a r a c t e r!

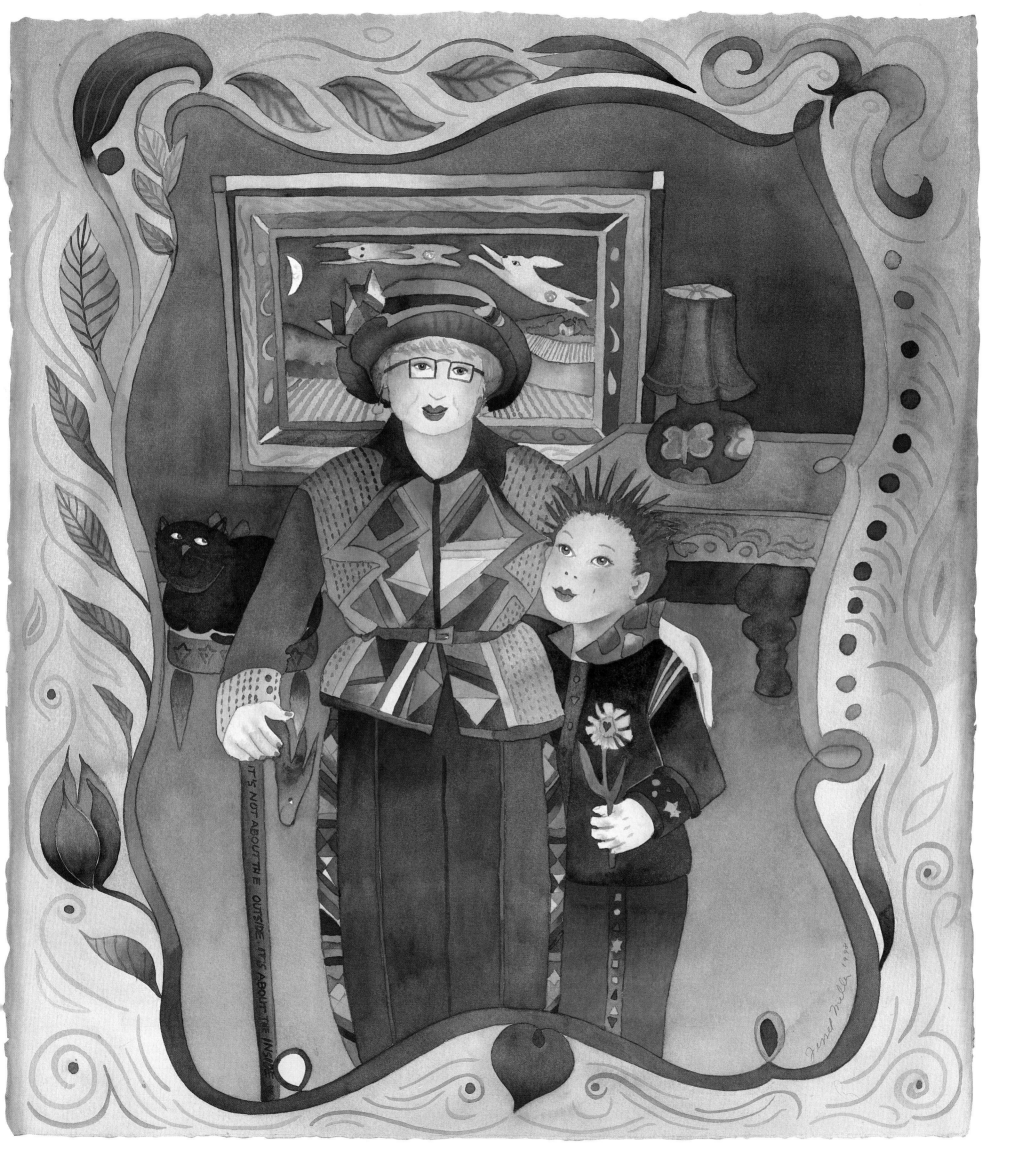

As a child, River wondered why people

should limit their giving

to holidays and celebrations.

His Mama told of a rabbit

who shares the

SPIRIT OF LOVE

ALL YEAR 'ROUND!

From Generous Rabbit, River discovered

that gifts can be given

for no reason at all.

So he dressed as the Rabbit,

gave gifts that he made

and food from his gardens,

and embraced every chance for sharing!

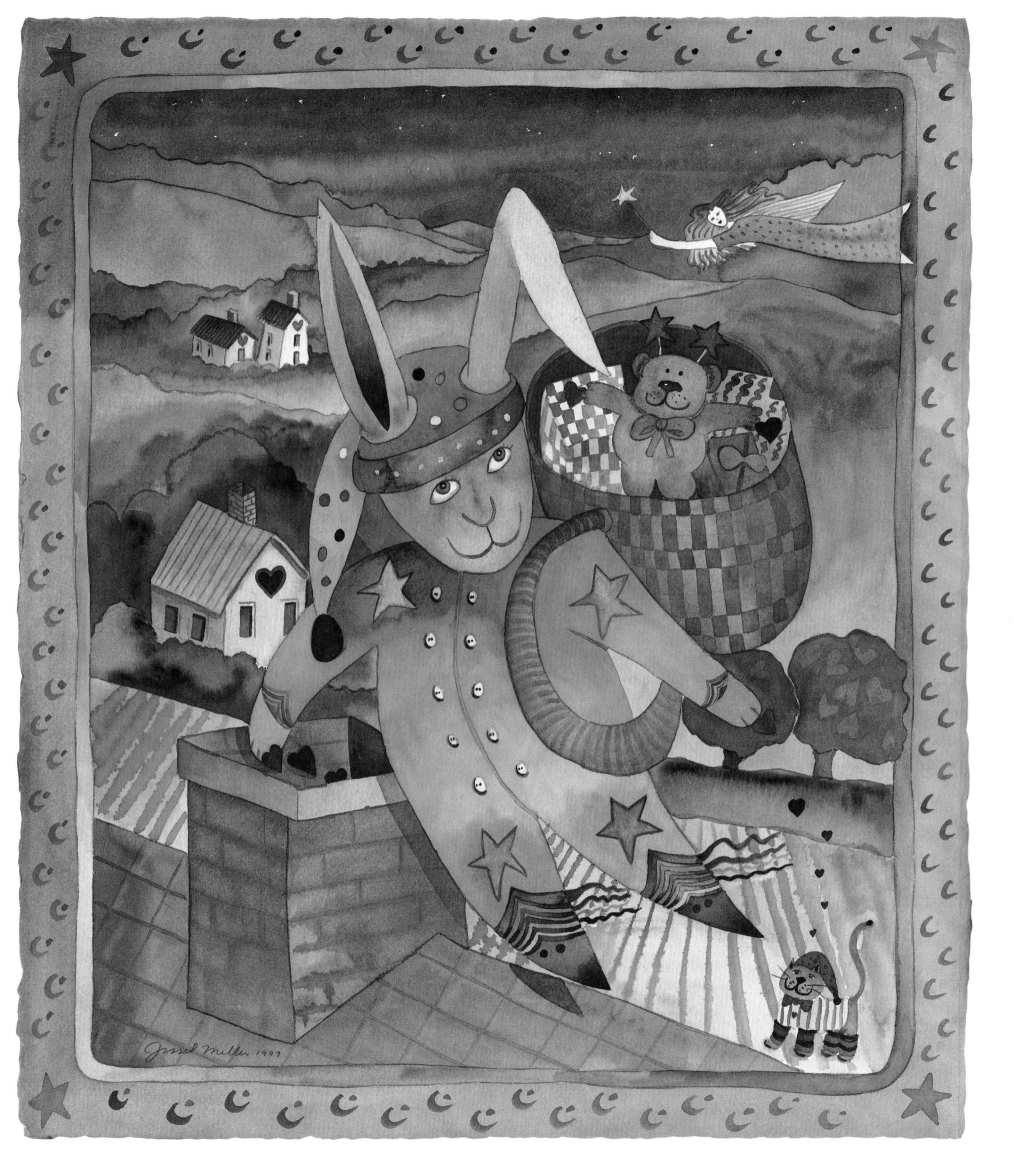

River watched his grandpa

build stone walls.

"Grandson," his grandpa said.

"Life, like these walls,

begins with a strong foundation.

You must be patient,

growing slowly inch by inch

and day by day."

And the walls were strong

and young River grew tall.

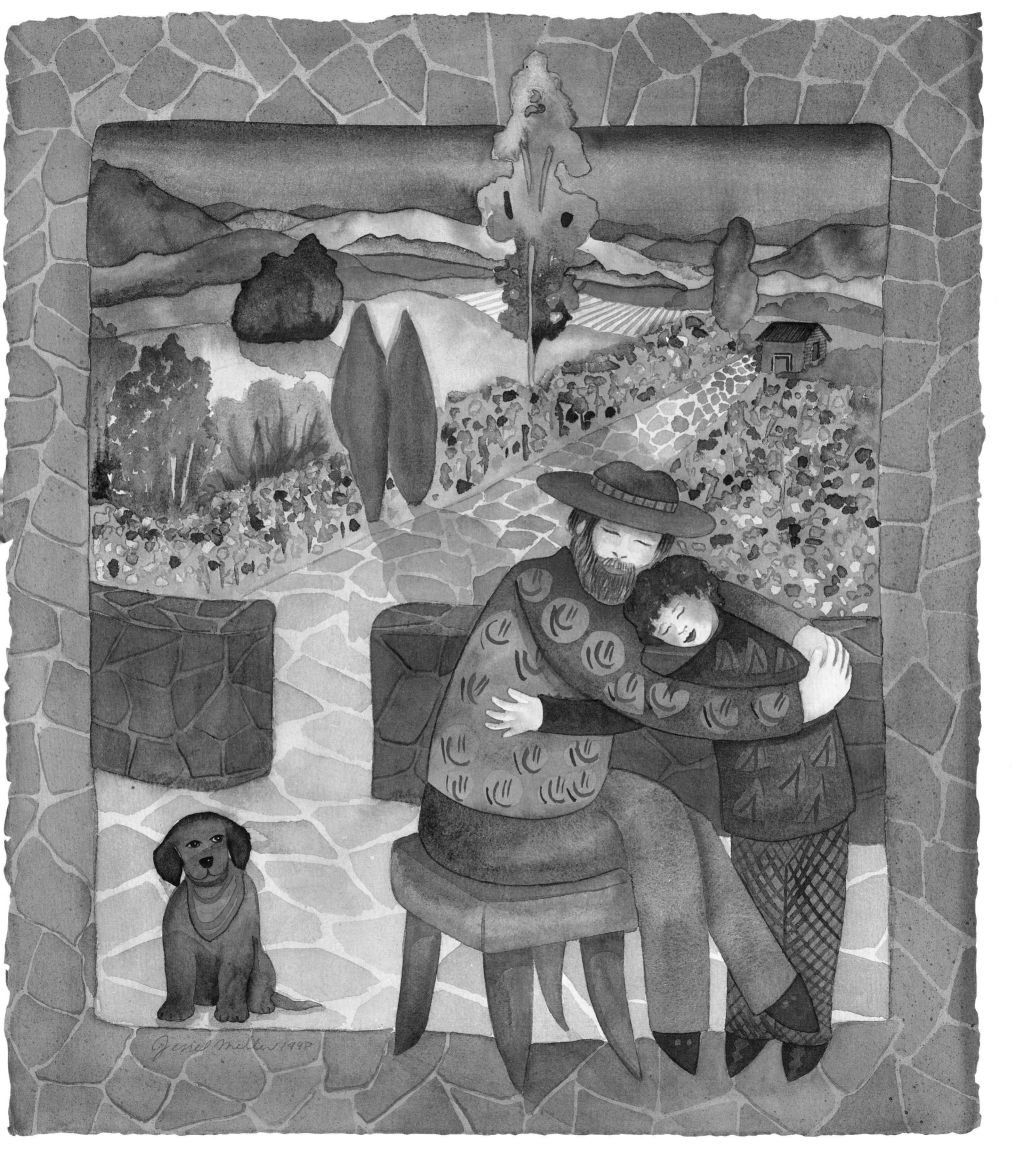

River told Mustard about visiting

his father at the summer cottage.

At dawn each morning,

his Papa took him fishing.

The light was rare and real at this

hour and Papa smiled.

"See the misty haze of light

and watch the morning breathe

in a new and glorious day.

Take time to touch

each moment with love,"

he said.

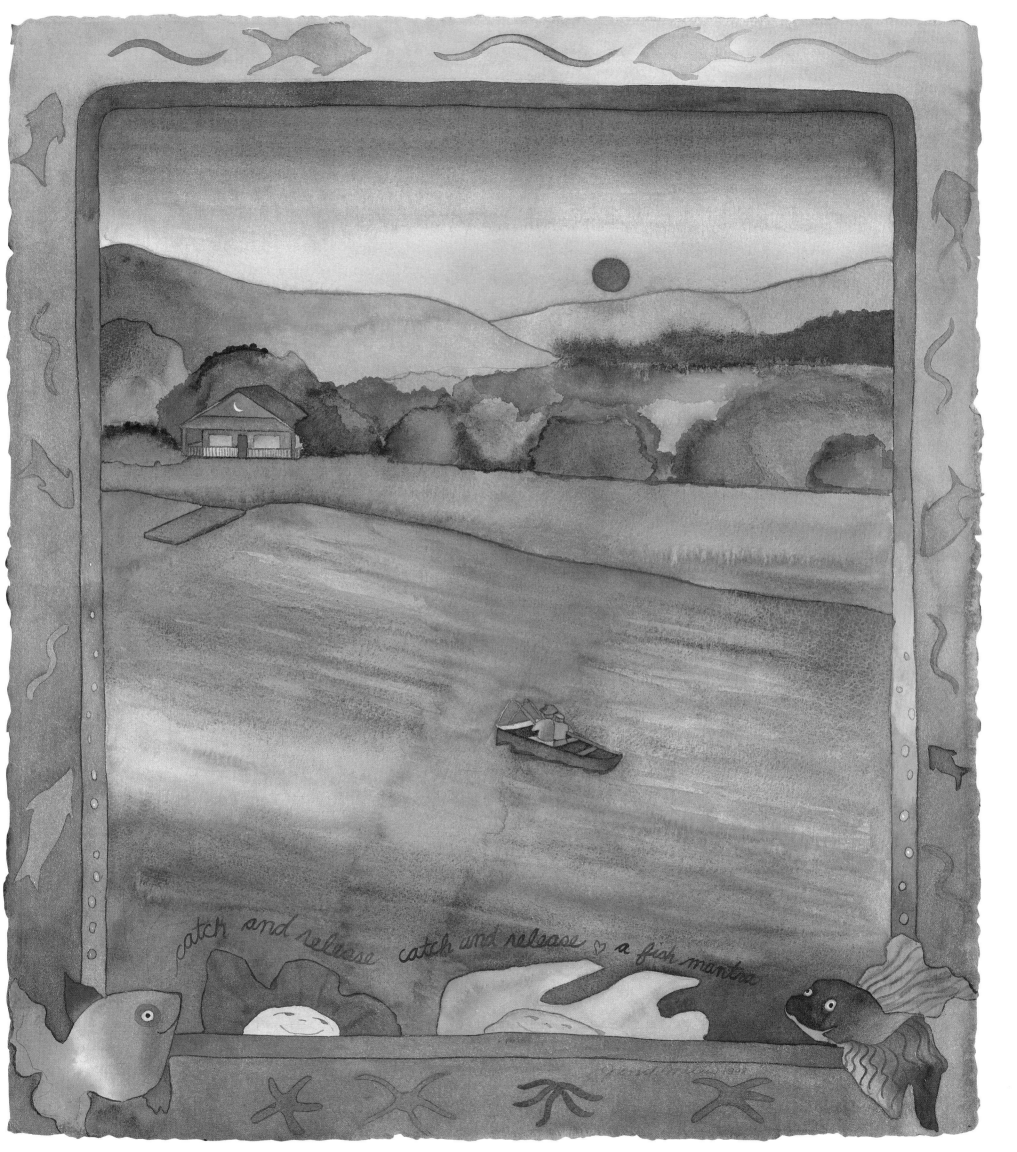

catch and release catch and release ♡ a fish mantra

After all the stories and

many years of special walks

and tender talks,

Mustard recognized that

this man was her soul mate.

River felt the same.

Mustard and River

believed in their hearts

that this was a match

ordained by all their loved ones

and all their Angel Guides.

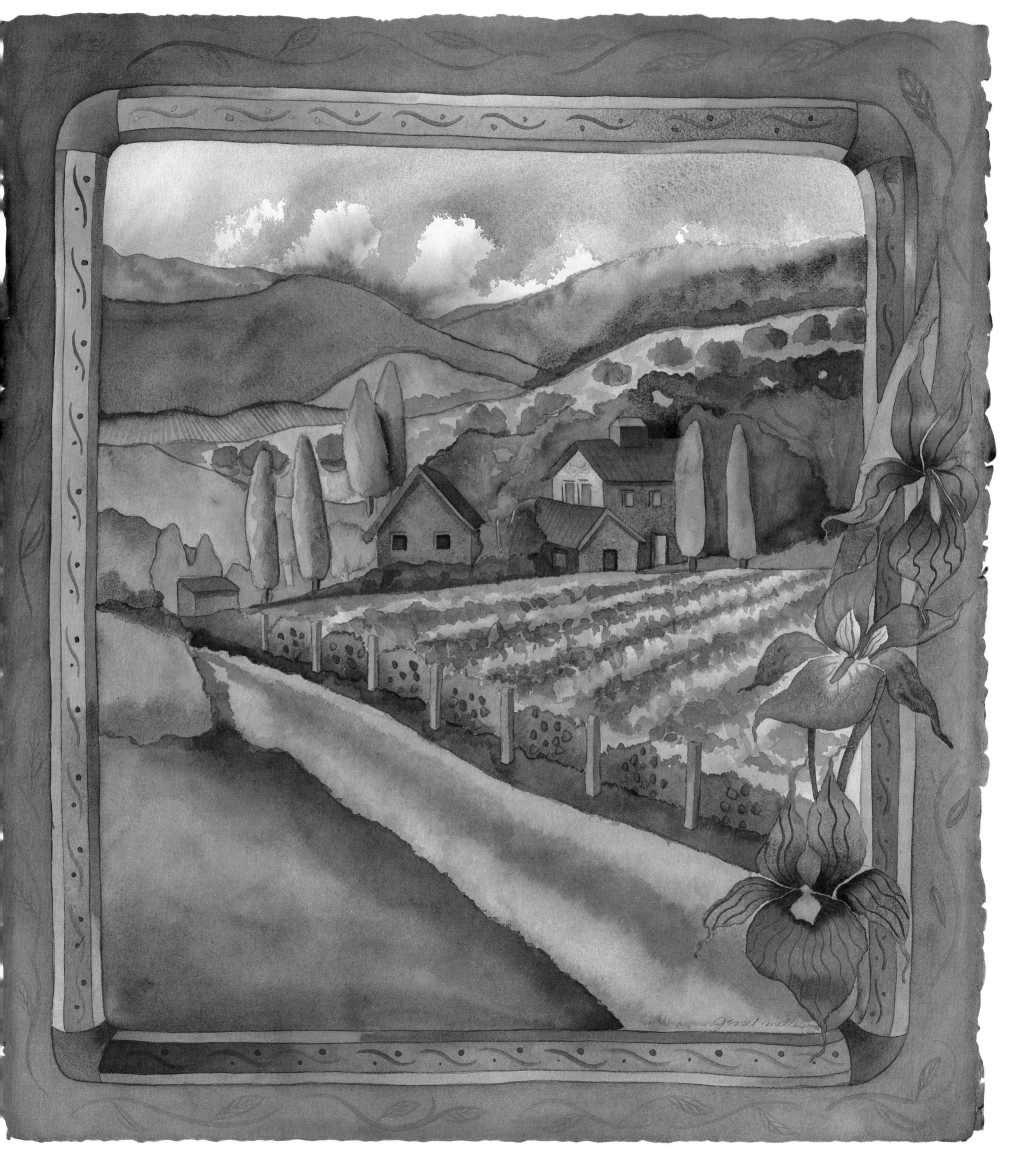

*T*heir love grew

 like eggs in a nest...

 like chickens from eggs...

 like kittens from cats...

 and harvest from the fields...

It was a blessed, natural love!

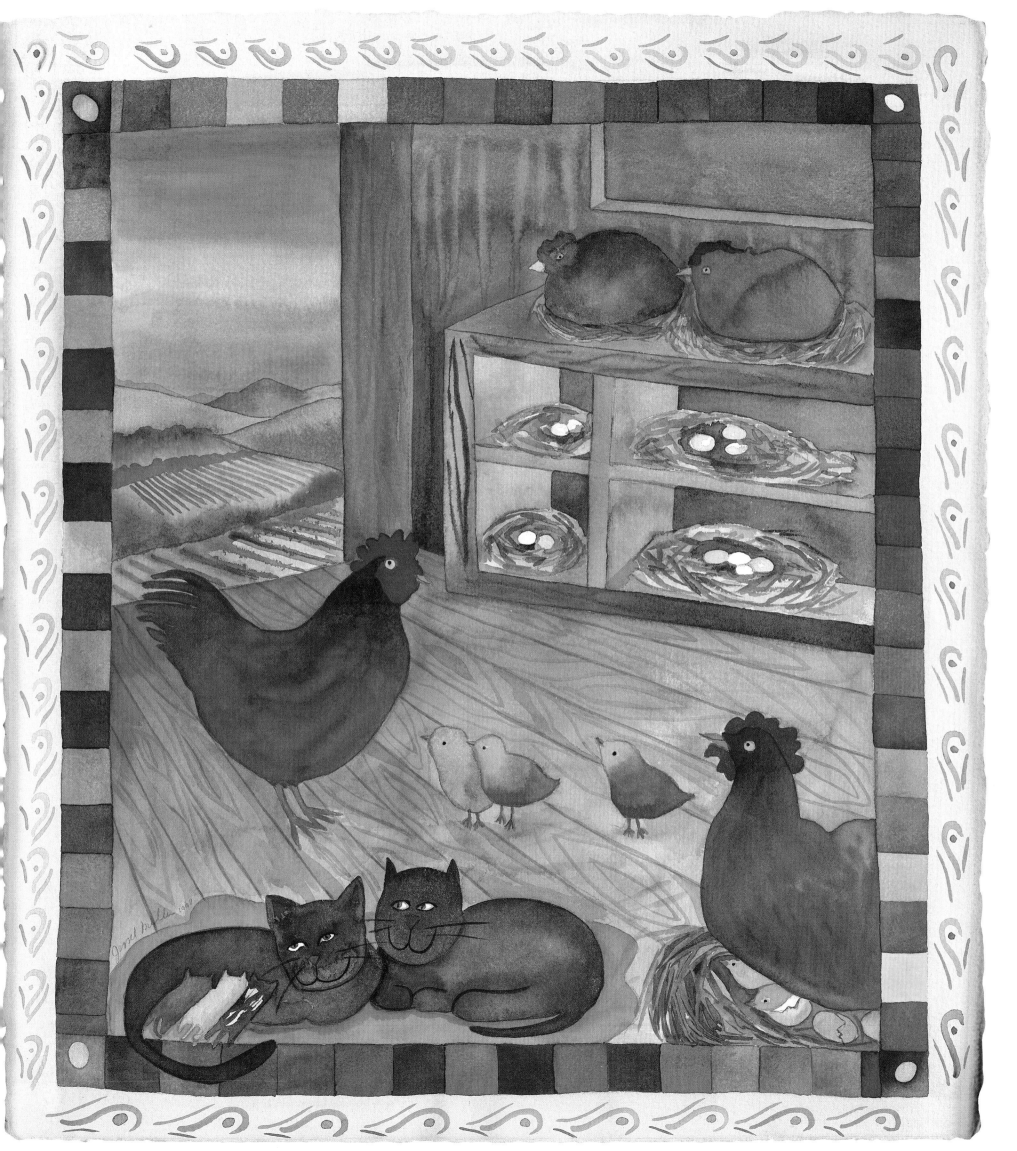

*O*ne splendid summer night

they gathered those they loved

in a circle ~ on a hillside.

And together they vowed:

"I am your beloved,

honest, devoted, and true

and willing to stand beside you,

firm and steady on this course called ~

L I F E.

Let us vow to stay open

and express our needs.

Let us promise to cherish each tear,

to treasure the mystery and

reach for the stars.

Together ~ forever ~ we share

Soft Love every day

and

Strong Values in every way."

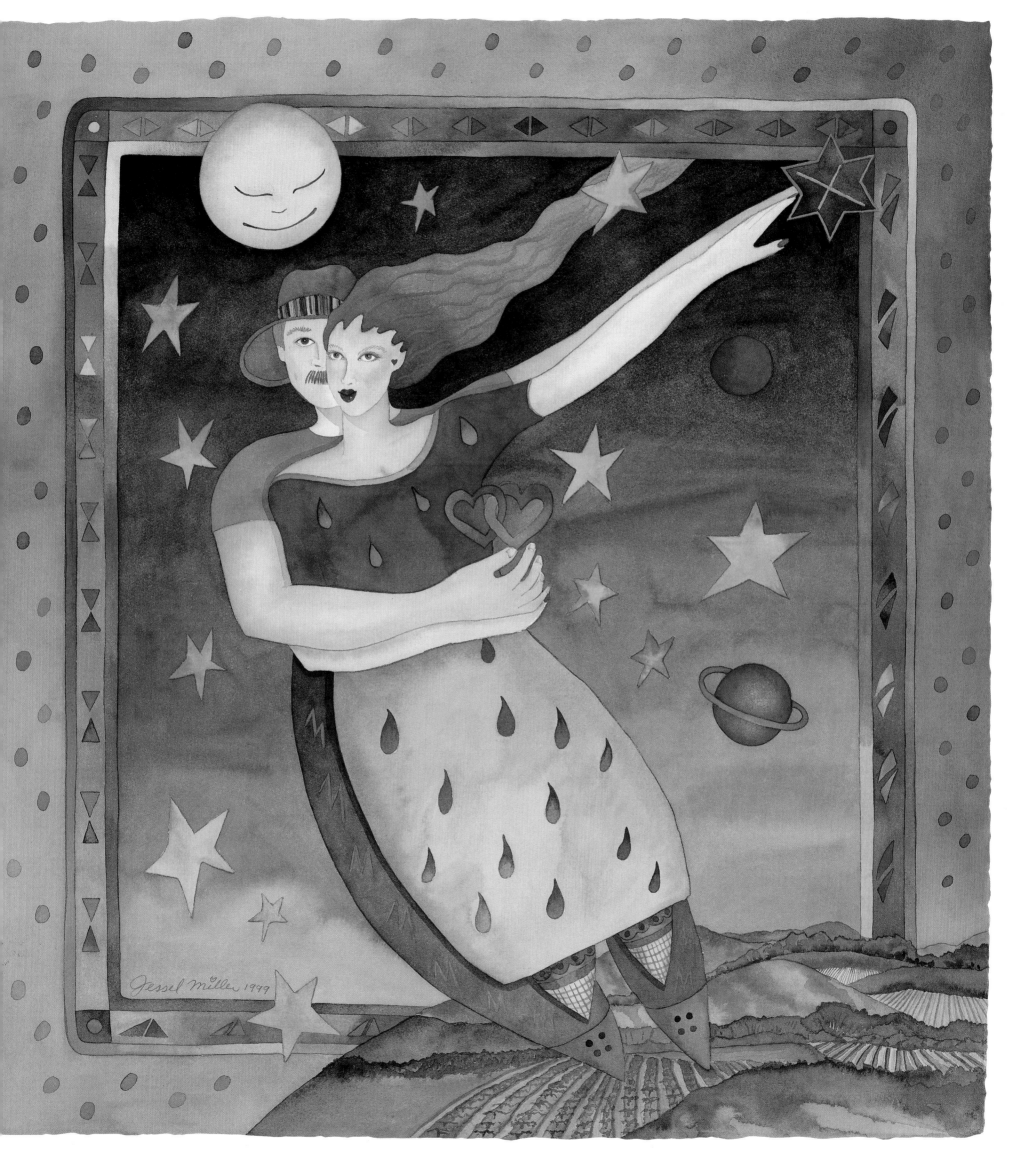

Two separate and powerful souls

joined in marriage,

committed to kindness and caring.

Their love was made of

compromise and sharing,

understanding and joy.

Mustard and River knew this was

HEAVEN ON EARTH.

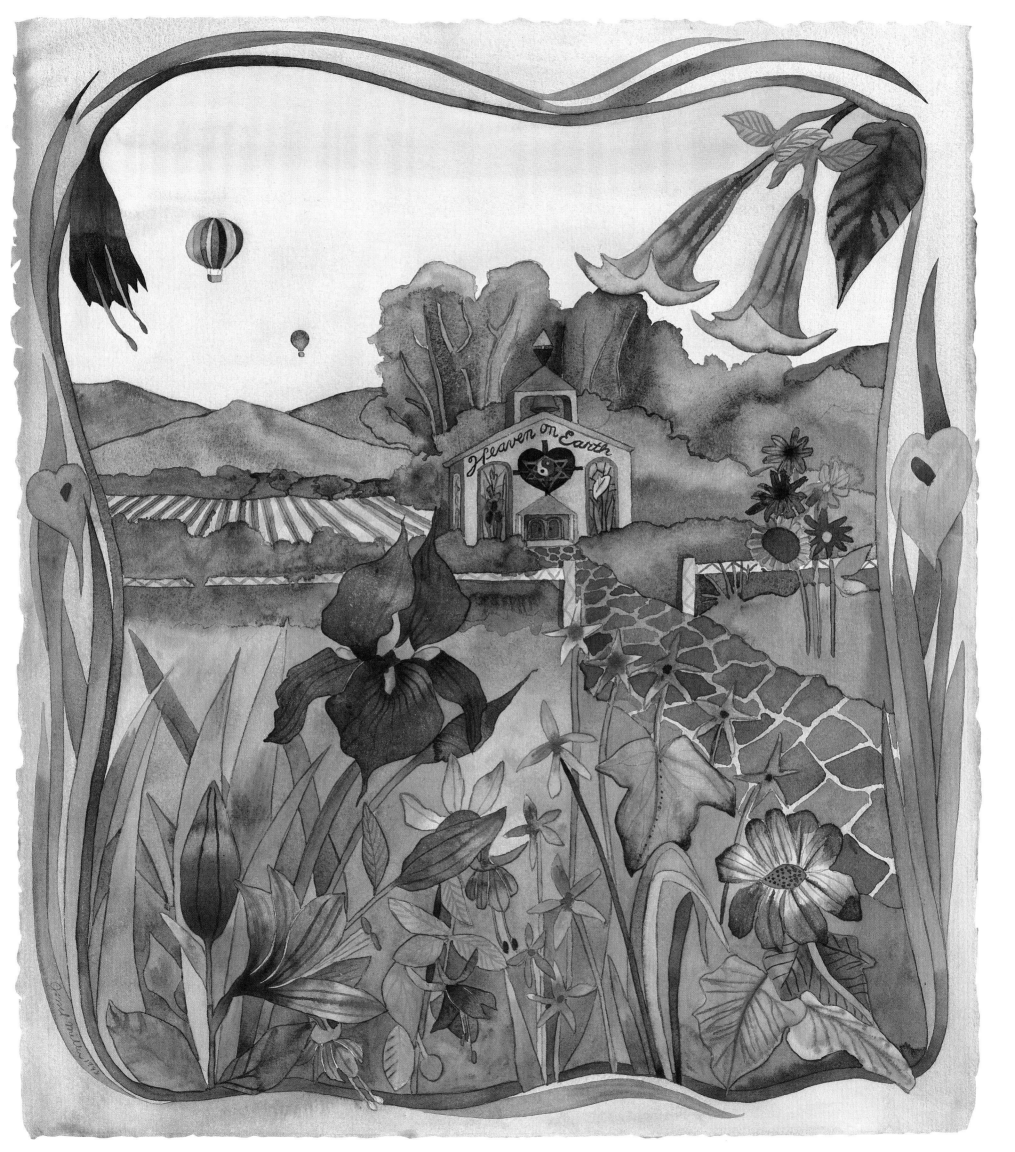

Their life u n f o l d e d

and together they shared

the richness of this love

with all those they touched.

From one tender moment

come eternal memories.

And in this love they discovered…

the true meaning of s u r r e n d e r.

Give up, let go, let love, let life u n f o l d !

Life's

circle

begins

again.

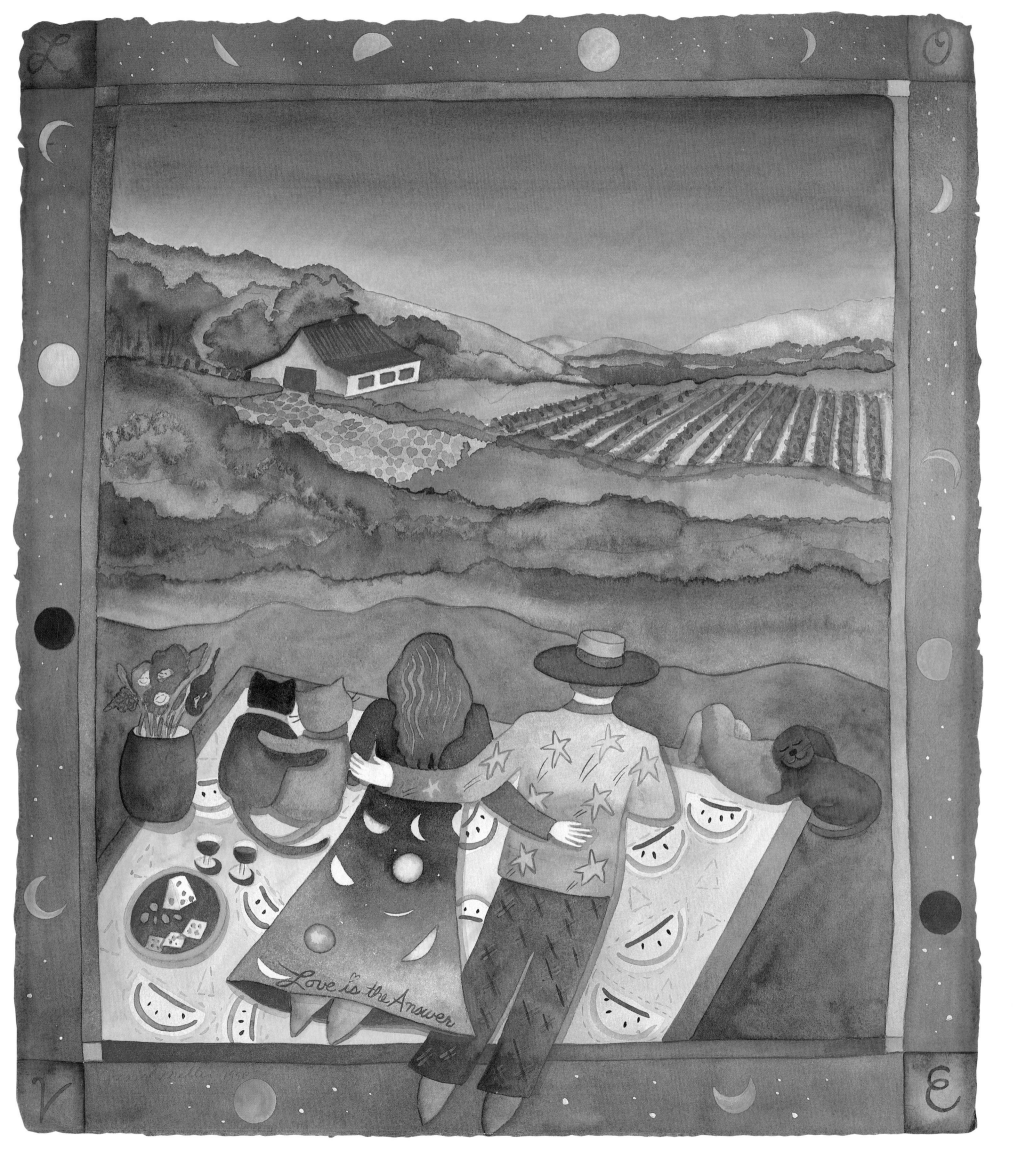

Love is the Answer

J E S S E L M I L L E R

Deep in the heart of the beautiful Napa Valley are the exquisite Jessel Gallery and Gary's Garden Shoppe. The Gallery was a seed Jessel planted in 1987, and for many years it has been voted "Best Art Experience in the Valley."

Today the Gallery is overflowing with creative talent, and the exterior abounds with fruiting vines and glorious flowers. Three hundred artists and craftspeople are represented. Jessel's fine art watercolors and prints are available, and next door Gary's Garden Shoppe offers home and garden gifts and accessories. The addition of Hedge Row Florist has completed the vision of a bountiful shopping wonderland.

The shops are open daily from 10 AM to 5 PM where fine art, flowers and gifts prevail in a most heartfelt, serene, and peaceful setting.

Jessel and Gary Miller met in 1990, and their love has grown to include not only the business, but also an extraordinary farm complete with chickens, golden retrievers, cats, ducks, giant pumpkins ~ plus fields of garden produce which are harvested and shared with the Napa Food Bank and family and friends. Your basic farm fantasy...

For more information about gifts and products from the
Mustard trilogy, order directly from:

Jessel Gallery
1019 Atlas Peak Road
Napa, CA 94558
888-702-6323 • voice
707-257-2396 • fax

MUSTARD (Book One) SOFT LOVE & STRONG VALUES
MUSTARD (Book Two) JOURNEY TO LOVE
MUSTARD (Book Three) LESSONS FROM OLD SOULS (available January, 2000)

SELECTED PRINTS FROM EACH BOOK ARE AVAILABLE

email: Jessel@Napanet.Net Web site: www.jesselgallery.com